OFF THE WALLS

INSPIRED RE-CREATIONS
OF ICONIC ARTWORKS

With a Preface by
Sarah Waldorf and Annelisa Stephan

GETTY PUBLICATIONS, LOS ANGELES

4
Preface
Sarah Waldorf and
Annelisa Stephan

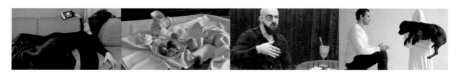

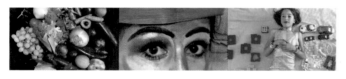

In March 2020 the COVID-19 pandemic brought life as we knew it to a halt. Much of the world retreated to a solitary life at home. Working remotely, we and other Getty colleagues asked ourselves how art could be a tonic for people through these uncertain times. Our community asked for fun, distraction, and education, too—and thus the art re-creation challenge was born. The prompt? Pick a favorite artwork, find three objects in your house, re-create the artwork with those items, and share with us online.

Re-creating art is a long, venerable, delightfully wacky tradition, from the *tableau vivant* to the museum selfie. For this challenge, we took inspiration from the Dutch Instagram account @tussenkunstenquarantaine, which translates to "between art and quarantine," but we added a Getty twist—we invited you to draw on our Open Content Program, which offers thousands of high-resolution images of art for free. Other museums around the world issued similar challenges to their followers, as did libraries, schoolteachers, and theaters, inviting kids and adults alike to look closely at book covers, film posters, album art, stamps, and more.

Millions of you saw our challenge posted on social media. Millions more saw it on the news. In a matter of weeks, we received hundreds of thousands of artwork re-creations from around the globe. They were

clever, hilarious, and poignant, and they were often served with a dash of social commentary.

You re-created Jeff Koons sculptures with socks and restaged Jacques-Louis David paintings with fleece blankets and duct tape. You MacGyvered costumes and backdrops out of towels, pillows, scarves, shower caps, coffee filters, bubble wrap, and—of course—toilet paper. You posed in your living rooms with extended family, alone with your best selfie sticks, in the hospital break room with fellow healthcare workers, and in studios with dramatic lighting. And you celebrated others' re-creations, applauding the creativity and resilience of friends, family, and Internet strangers.

Van Gogh and Vermeer were popular sources of inspiration, especially *The Starry Night* (done to perfection with spaghetti and cleaning products) and *Girl with a Pearl Earring* (restaged with selfies, grandma, puppies, even corn). Grant Wood's *American Gothic* captured the socially distant mood. Munch's *The Scream* was a favorite for people of all ages, and even looked good rendered in jam on toast.

We are endlessly grateful for the Internet's embrace of this challenge. It speaks to the power of art to bond us together. Art invites us into the experience of others and connects us with our shared past. In isolation, a sense of community is sacred—and we're over the moon that this challenge connected so many fellow art lovers around the world.

To everybody who sent in a re-creation, this book belongs to you . . . and to your friends and family who may or may not have been forced to pose with you. Enjoy.

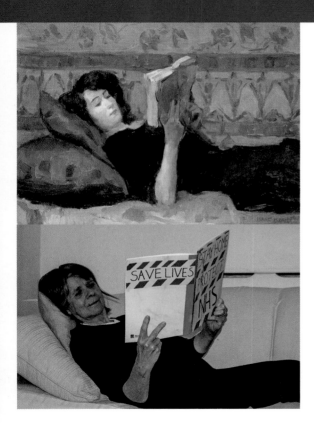

Isaac Israels
Girl Reading on a Sofa, 1920

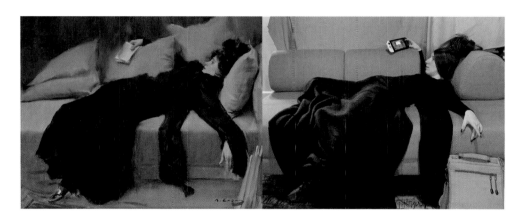

Ramón Casas
Decadent Young Woman: After the Dance, 1899

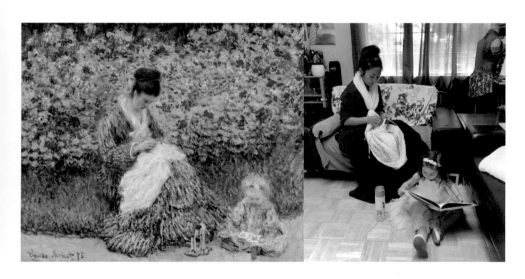

Claude Monet
Camille Monet and a Child in the Artist's Garden in Argenteuil, 1875

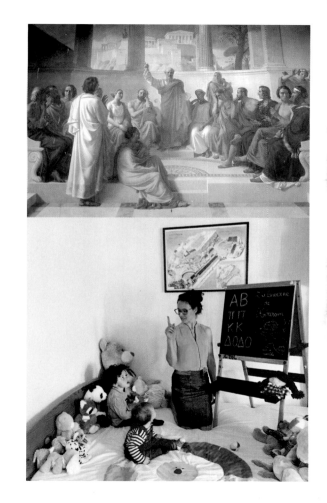

Sébastien Louis Guillaume Norblin
de la Gourdaine
Saint Paul in Athens, 1844

9

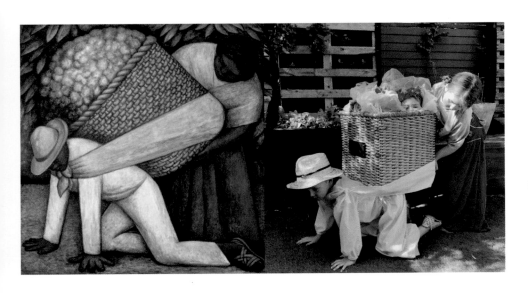

Diego Rivera
The Flower Carrier, 1935

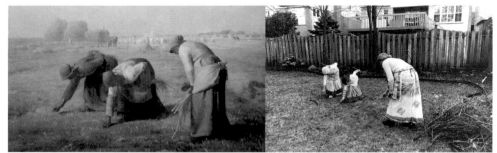

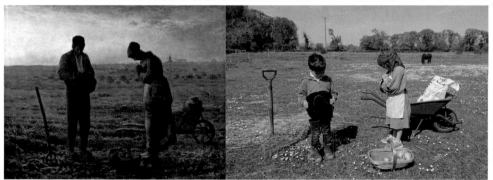

Jean-François Millet
Gleaners, 1857

Jean-François Millet
The Angelus, 1857–59

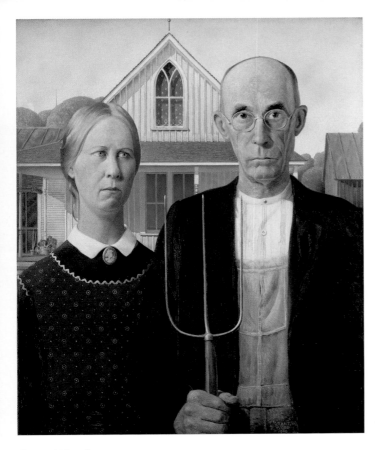

Grant Wood
American Gothic, 1930

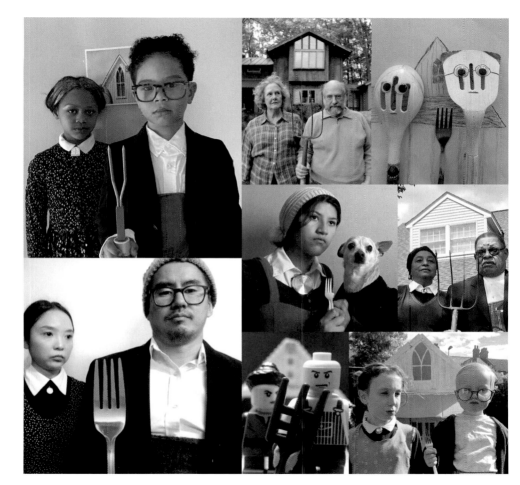

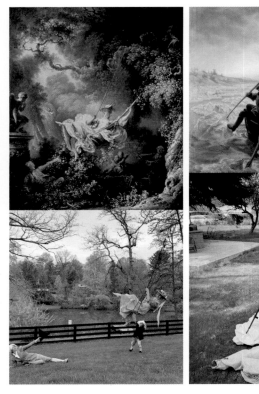

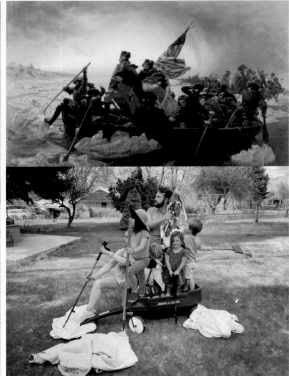

Jean-Honoré Fragonard
The Swing (detail), ca. 1767

Emanuel Leutze
Washington Crossing the Delaware, 1851

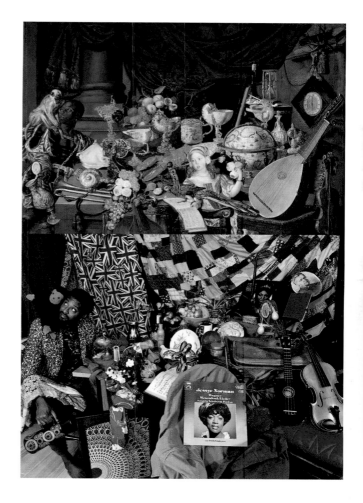

Unknown Artist
The Paston Treasure, 1663

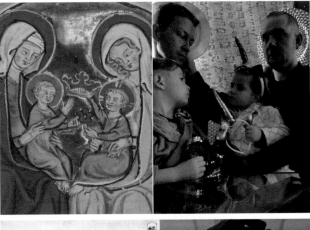

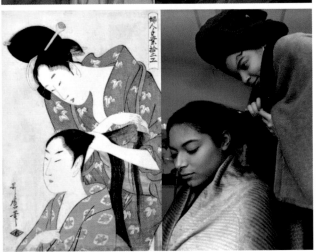

< Unknown Swiss Artist
*Initial G: The Virgin, Saint Elizabeth,
and the Infants John the Baptist and
Christ* (detail), ca. 1300

> Kitagawa Utamaro
Hairdresser (Kamiyui), ca. 1797–98

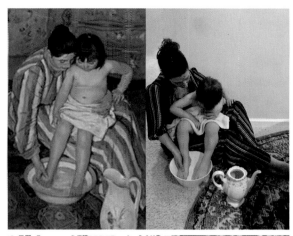

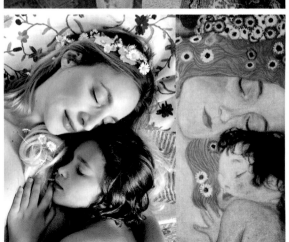

< Mary Cassatt
The Child's Bath, 1893

> Gustav Klimt
The Three Ages of Woman (detail), 1905

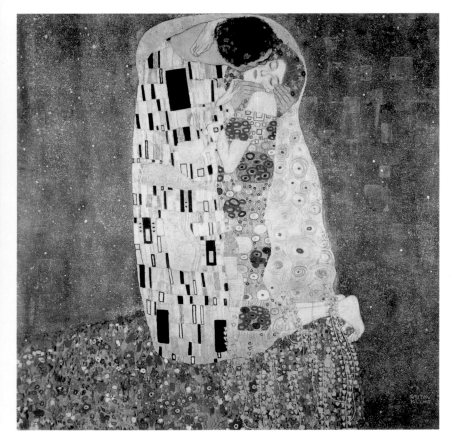

Gustav Klimt
The Kiss, 1907–8

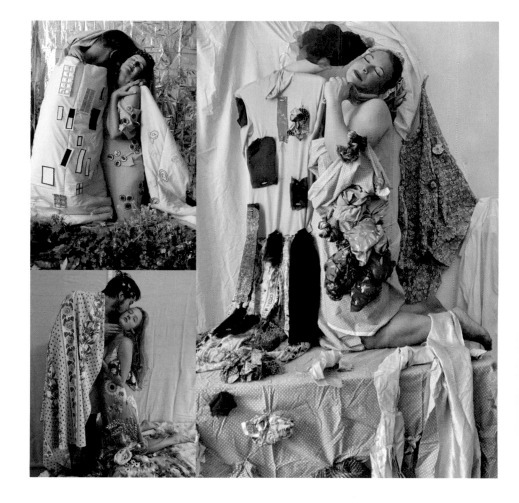

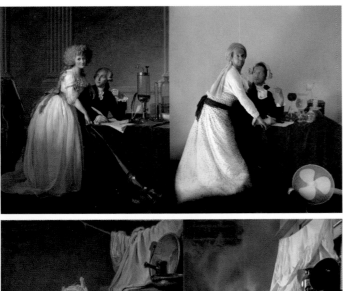

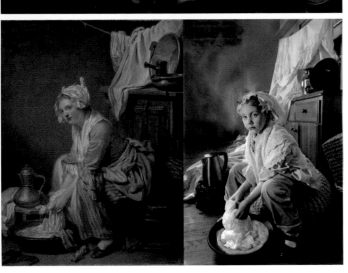

< Jacques-Louis David
*Antoine Laurent Lavoisier (1743–1794)
and His Wife (Marie-Anne Pierrette
Paulze, 1758–1836)*, 1788

> Jean-Baptiste Greuze
The Laundress, 1761

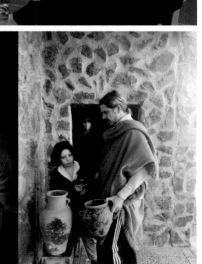

< Unknown Artist
Monk with Wine, ca. 1900

> Diego Velázquez
The Waterseller of Seville, 1618–22

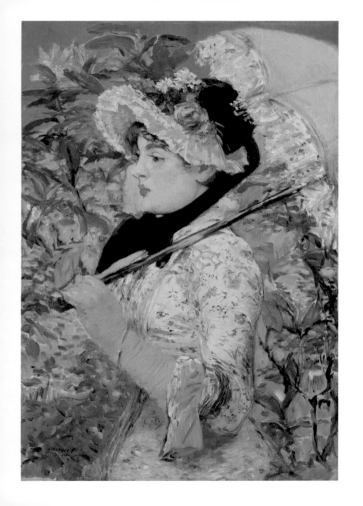

Édouard Manet
Jeanne (Spring), 1881

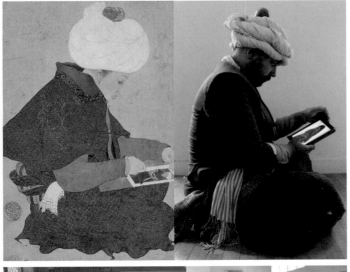

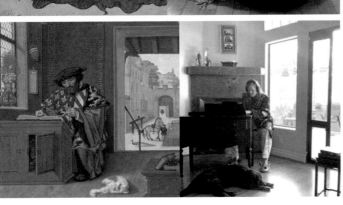

< Unknown Ottoman Artist
Portrait of a Painter, late 15th century

> Simon Bening
*The King of Arms of the Order of the
Golden Fleece Writing about Jacques de
Lalaing*, ca. 1530

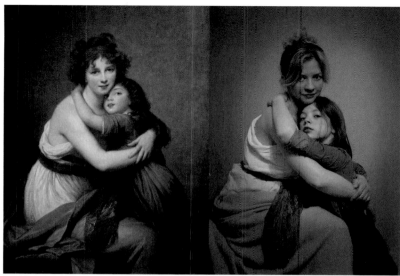

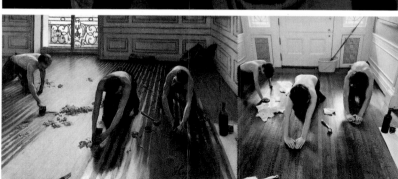

< Élisabeth Louise Vigée-LeBrun
Self-Portrait with Her Daughter, 1789

> Gustave Caillebotte
The Floor Scrapers, 1875

25

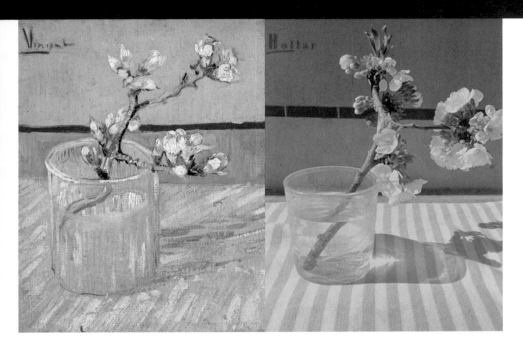

Vincent van Gogh
Sprig of Flowering Almond in a Glass, 1888

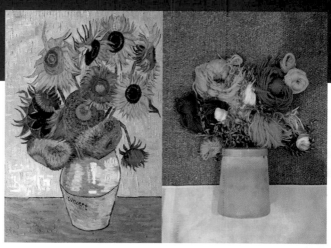

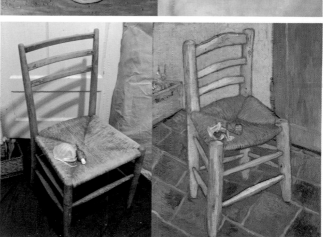

< Vincent van Gogh
Sunflowers, 1888

> Vincent van Gogh
Van Gogh's Chair, 1888

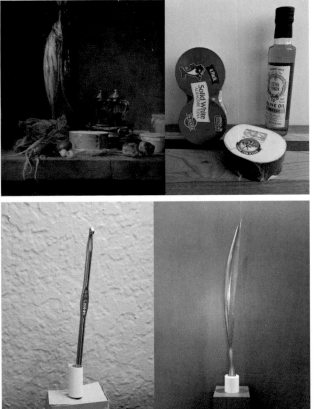

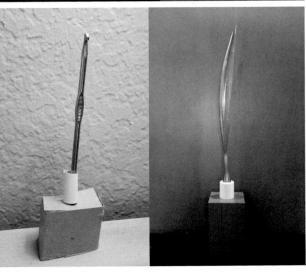

< Jean-Siméon Chardin
Still Life with Fish, Vegetables, Gougères,
Pots, and Cruets on a Table, 1769

> Constantin Brancusi
Bird in Space, 1928

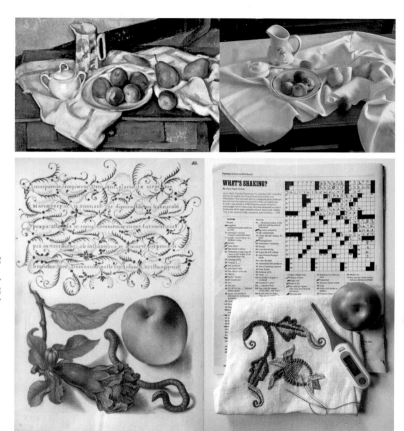

< Paul Cézanne
Peaches and Pears, 1890–94

> Joris Hoefnagel and Georg Bocskay
Pomegranate, Worm, and Peach, 1561–62;
illumination added 1591–96

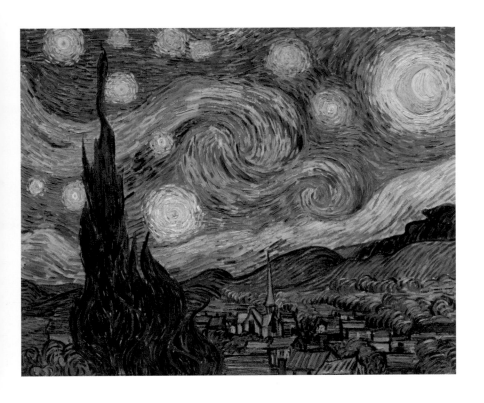

Vincent van Gogh
The Starry Night, 1889

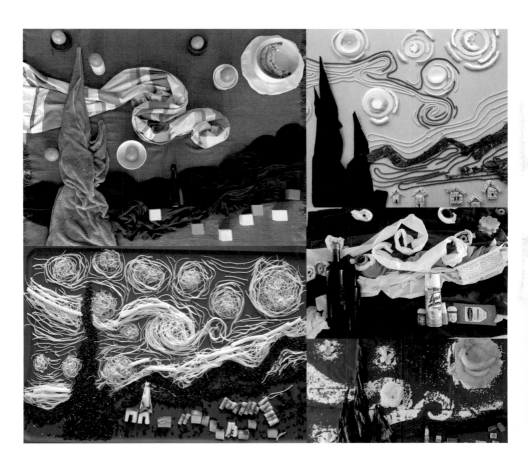

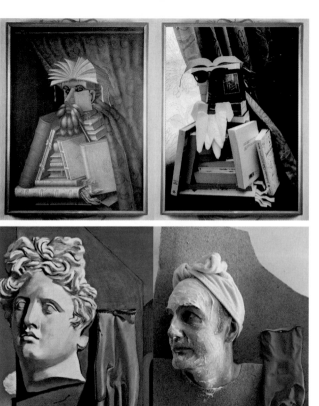

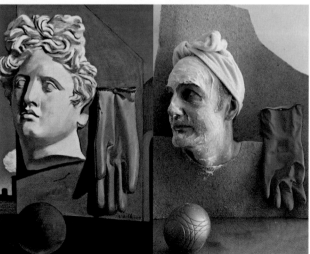

< Giuseppe Arcimboldi
The Librarian, ca. 1566

> Giorgio de Chirico
The Song of Love, 1914

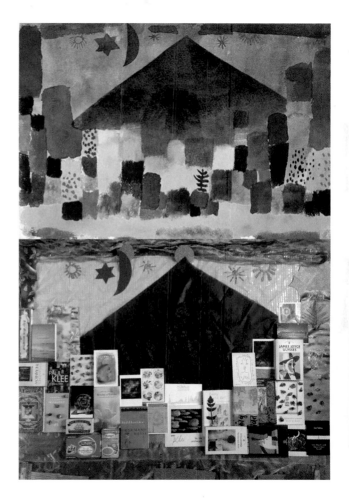

Paul Klee
Mount Niesen, 1915

33

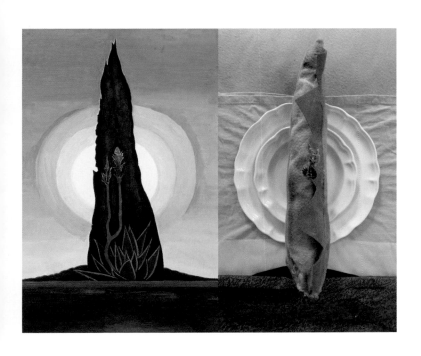

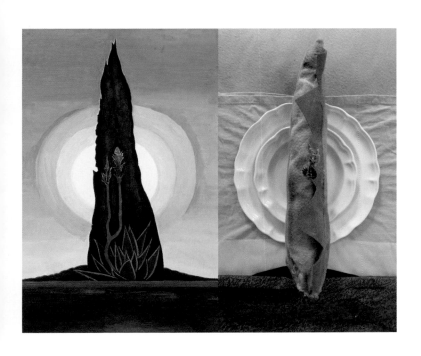

Joseph Stella
Tree, Cactus, Moon, ca. 1928

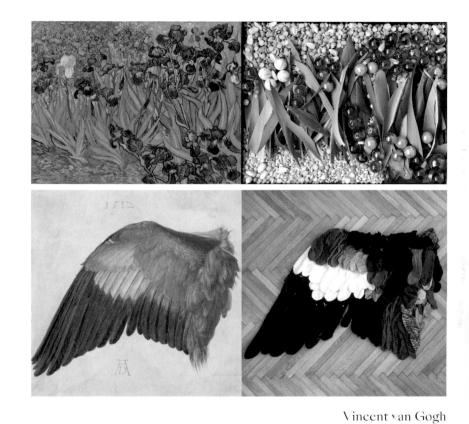

Vincent van Gogh
Irises, 1889

Albrecht Dürer
Wing of a Blue Roller, ca. 1500

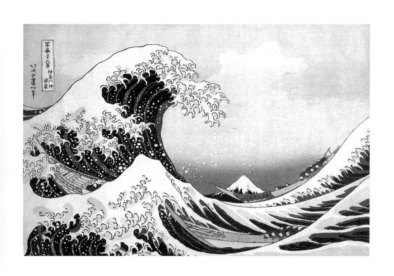

Katsushika Hokusai
Under the Wave off Kanagawa (The Great Wave), 1830–32

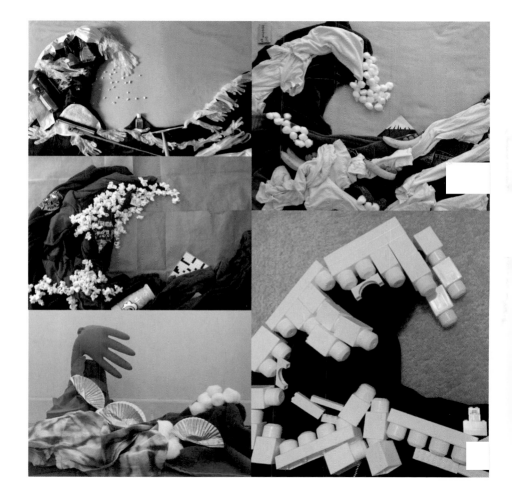

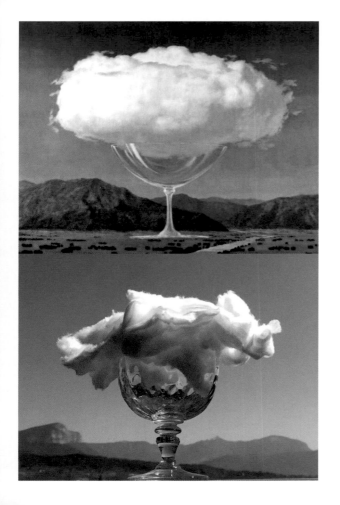

René Magritte
The Heartstrings, 1960

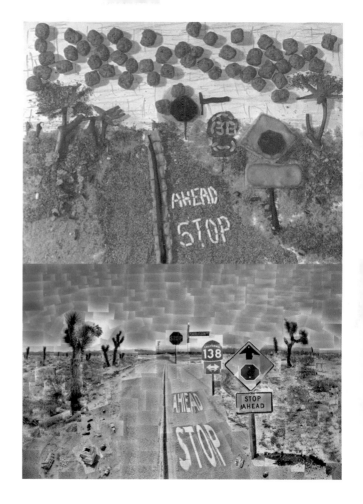

David Hockney
*Pearblossom Hwy., 11–18th April 1986
(Second Version)*, 1986

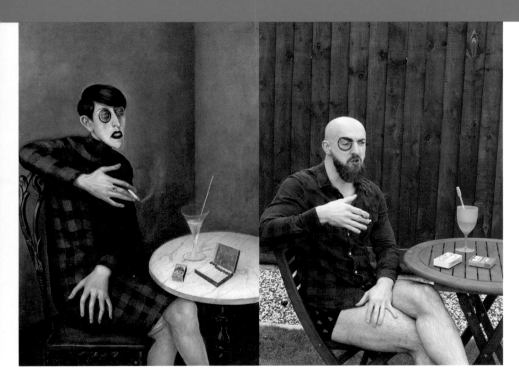

Otto Dix
Portrait of the Journalist Sylvia von Harden, 1926

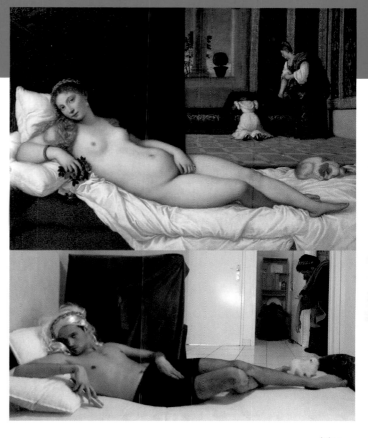

Titian
Venus of Urbino, 1538

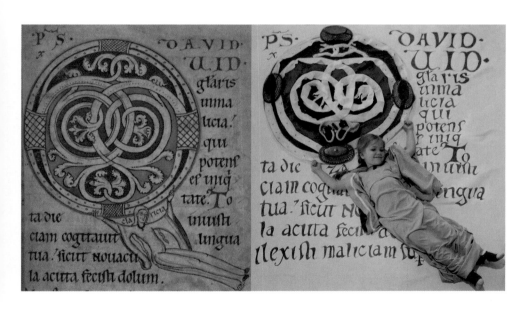

Unknown Artist
Initial O, from the *Claricia Psalter,* late 12th–early 13th century

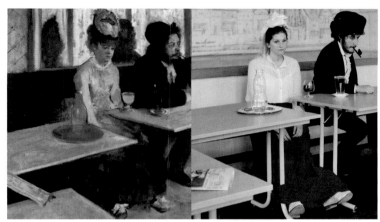

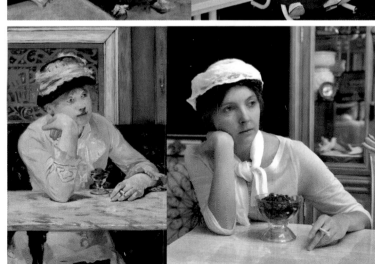

< Edgar Degas
In a Café (Absinthe), 1875–76

> Édouard Manet
Plum Brandy, ca. 18——

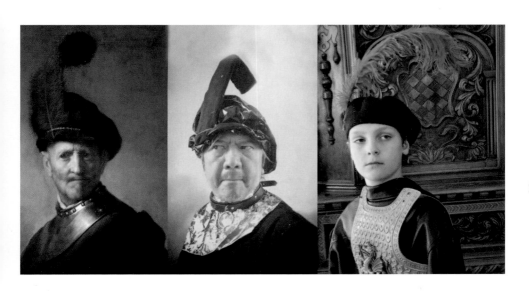

Rembrandt Harmensz. van Rijn
An Old Man in Military Costume (detail), ca. 1630–31

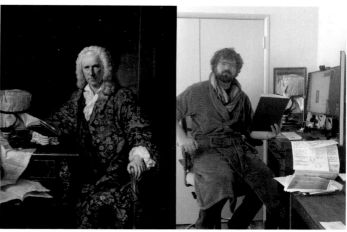

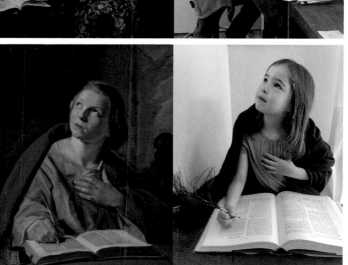

< Jacques-André-Joseph Aved
Portrait of Marc de Villiers, 1747

> Frans Hals
Saint John the Evangelist, ca. 1625–28

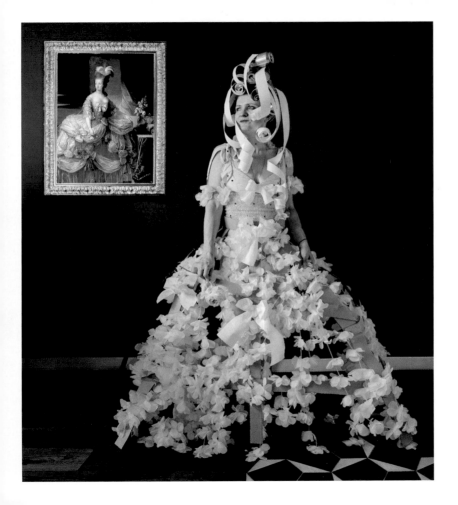

Élisabeth Louise Vigée-LeBrun
Marie Antoinette in Court Dress, 1778

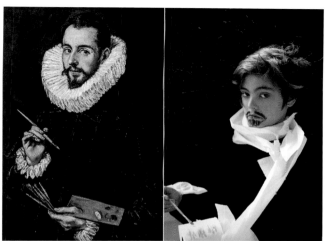

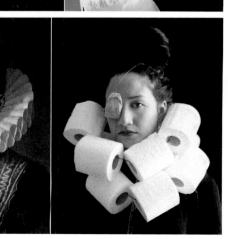

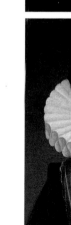

< El Greco
Portrait of Jorge Manuel Theotokopoulos,
1600–1605

> Alonso Sánchez Coello
*Ana de Mendoza de la Cerda, Princess
of Éboli*, 16th century

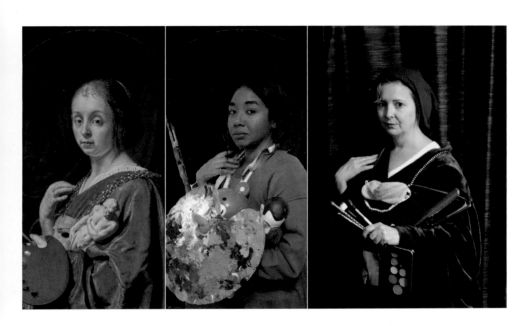

Frans van Mieris the Elder
Pictura (An Allegory of Painting), 1661

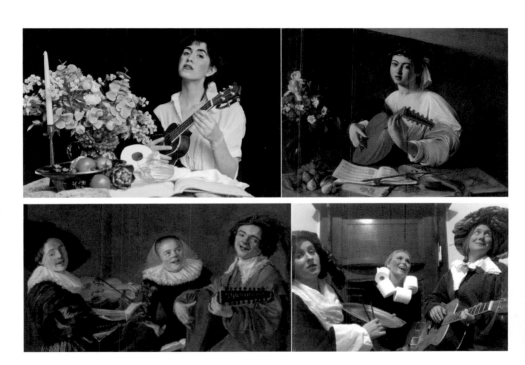

Michelangelo Merisi da Caravaggio
The Lute Player, ca. 1596

Judith Leyster
The Concert, 1631–33

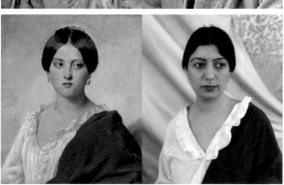

< Vincent van Gogh
Self-Portrait, 1889

> Franz Xaver Winterhalter
Portrait of an Italian Girl, ca. 1834

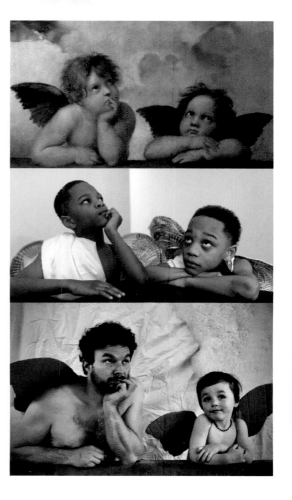

Raphael
Sistine Madonna (detail), 1512

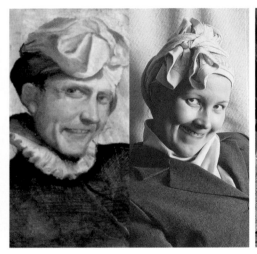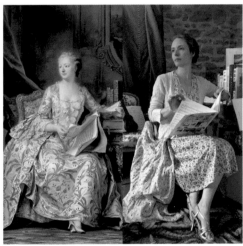

Annibale Carracci
Head of a Laughing Youth, 1583

Maurice-Quentin de La Tour
Portrait of the Marquise de Pompadour, 1748–55

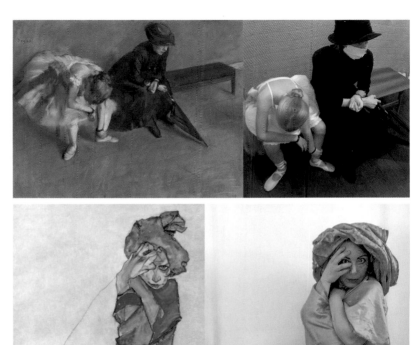

< Edgar Degas
Waiting, ca. 1882

> Egon Schiele
Kneeling Female in Orange-Red Dress, 1910

53

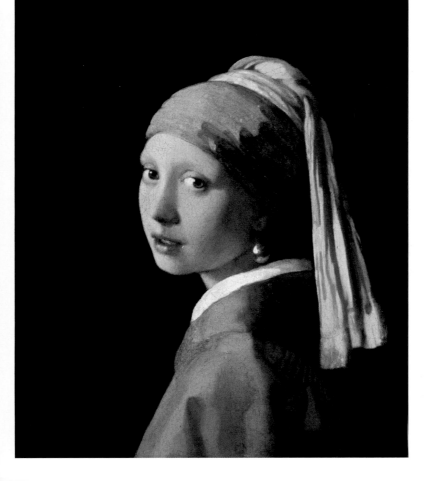

Johannes Vermeer
Girl with a Pearl Earring, ca. 1665

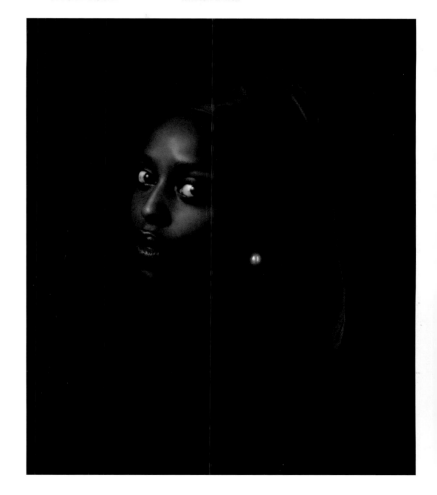

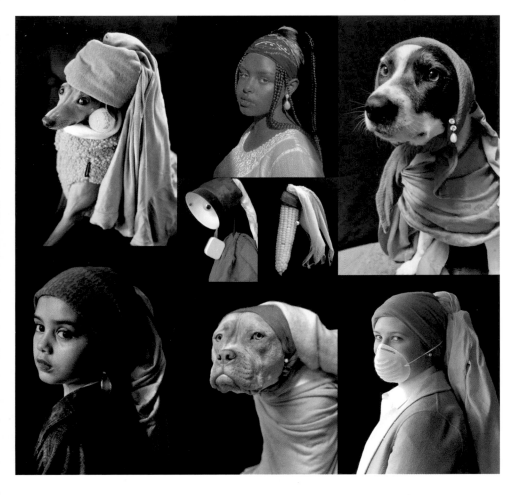

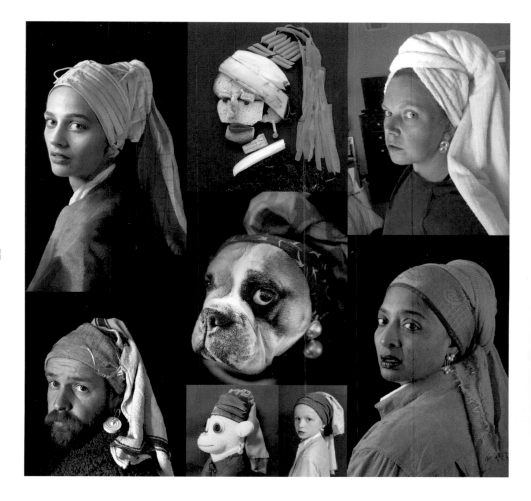

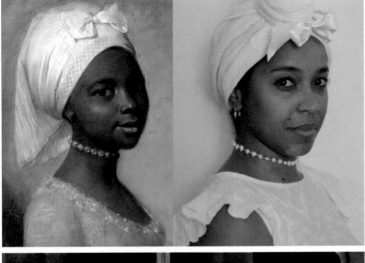

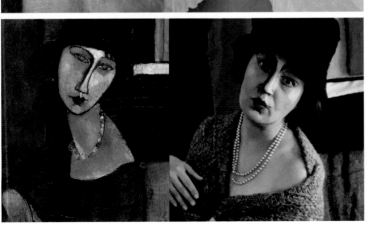

< Jean-Étienne Liotard
Portrait of a Young Woman,
late 18th century

> Amedeo Modigliani
Jeanne Hébuterne with Hat and Necklace,
1917

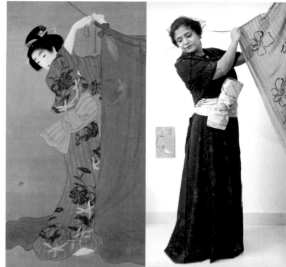
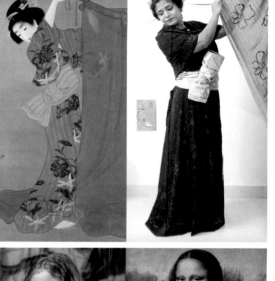

< Uemura Shōen
Firefly, 1913

> Leonardo da Vinci
Mona Lisa, ca. 1503–19

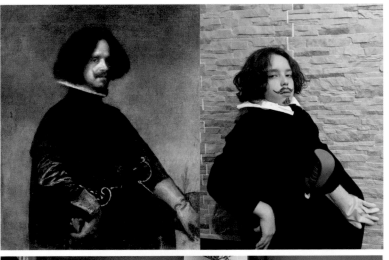

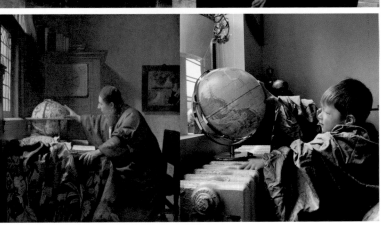

< Diego Velázquez
Self-Portrait, ca. 1645

> Johannes Vermeer
The Astronomer, 1668

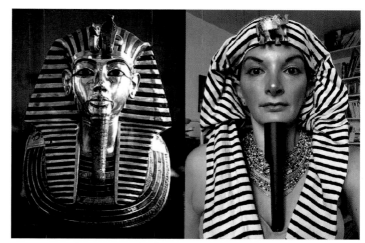

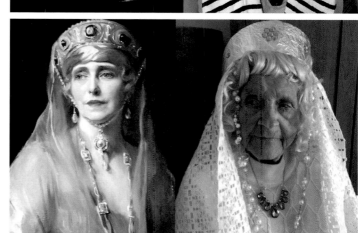

< Unknown Egyptian Artist
Mask of Tutankhamun, 1323 BCE

> Philip de Laszlo
Queen Marie of Romania, 1924

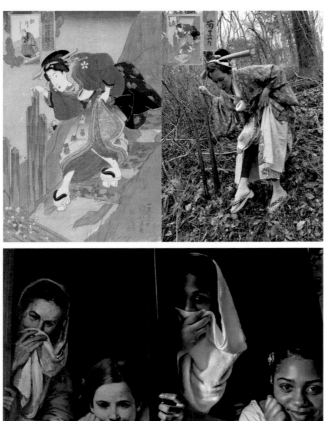

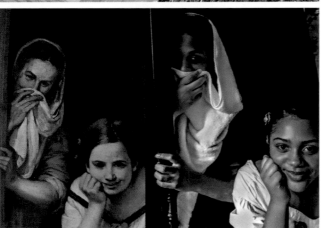

< Utagawa Kuniyoshi
Boarding a Boat (Funazucatariyo), 1830

> Bartolomé Esteban Murillo
Two Women at a Window (detail),
ca. 1655–60

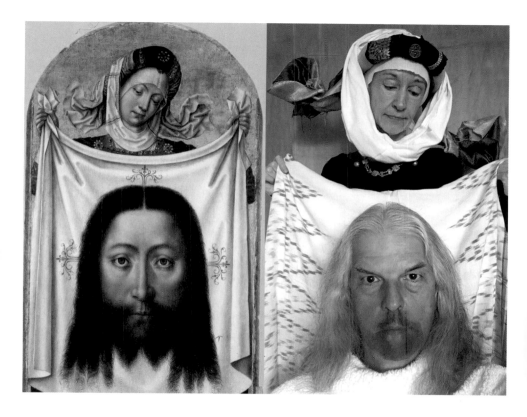

Master of the Legend of Saint Ursula
Saint Veronica with the Sudarium, 1480–1500

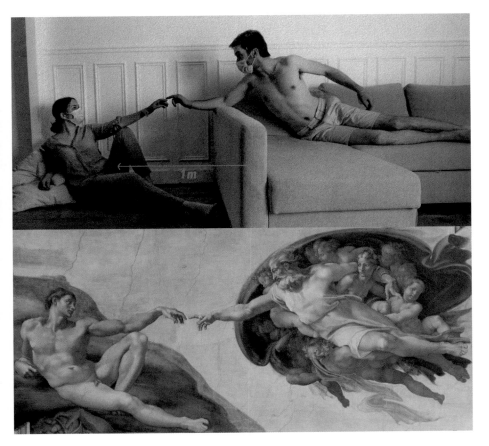

Michelangelo Buonarroti
The Creation of Adam, ca. 1508–12

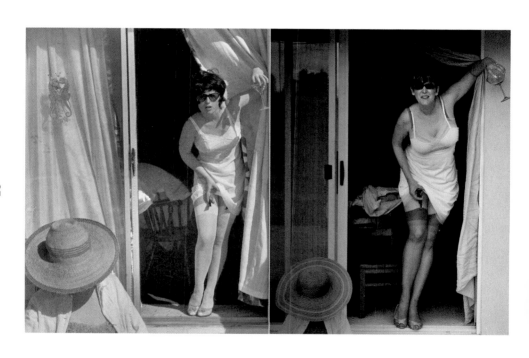

Cindy Sherman
Untitled Film Still #7, 1978

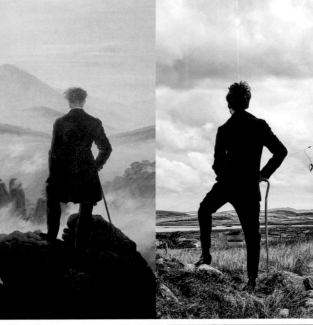

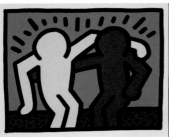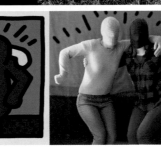

< Caspar David Friedrich
Wanderer above the Sea of Fog, 1818

> Keith Haring
Untitled (from the Pop Shop I series),
1987

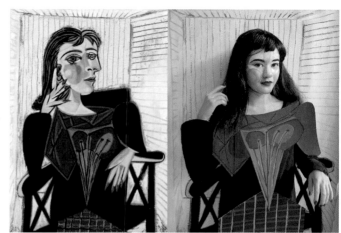

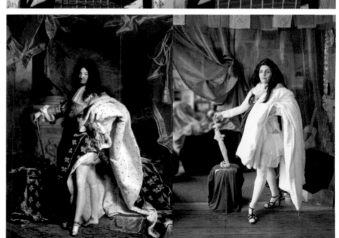

< Pablo Picasso
Portrait of Dora Maar, 1937

> Hyacinthe Rigaud
Portrait of Louis XIV, 1701

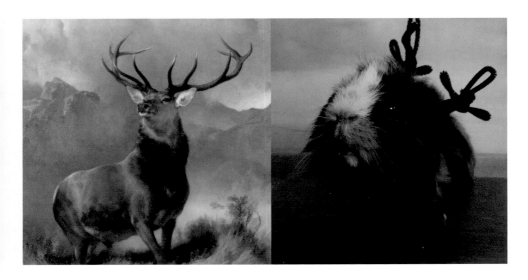

Edwin Landseer
The Monarch of the Glen, ca. 1851

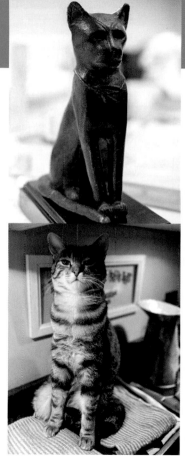
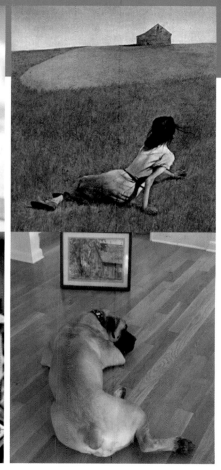

∧ Andrew Wyeth
Christina's World, 1948

∨ Unknown Egyptian Artist
Statuette of Bast in the Form of a Cat,
4th–1st century BCE

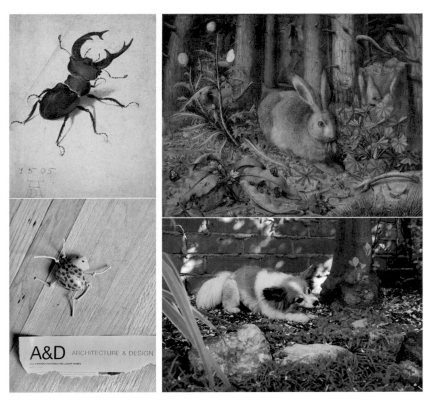

< Albrecht Dürer
Stag Beetle, 1505

> Hans Hoffmann
A Hare in the Forest, ca. 1585

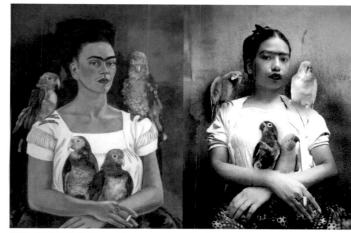

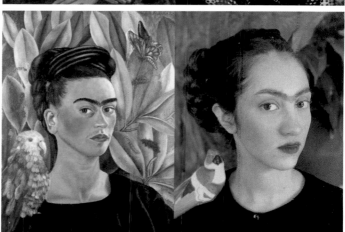

< Frida Kahlo
Me and My Parrots, 1941

> Frida Kahlo
Self-Portrait with Bonito, 1941

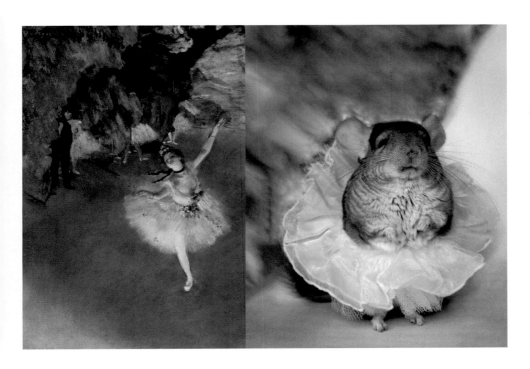

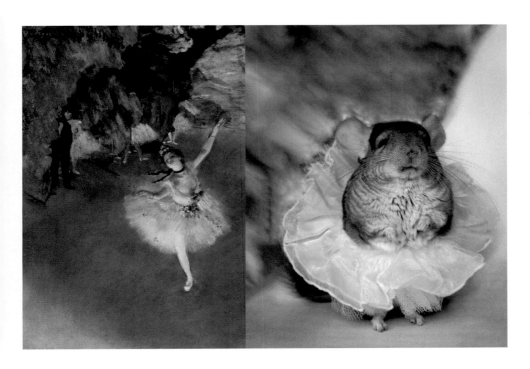

Edgar Degas
The Star, ca. 1876

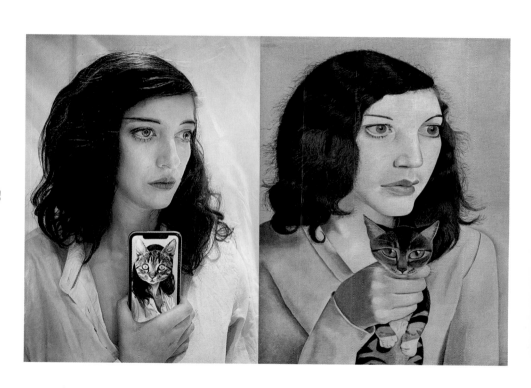

Lucian Freud
Girl with a Kitten, 1947

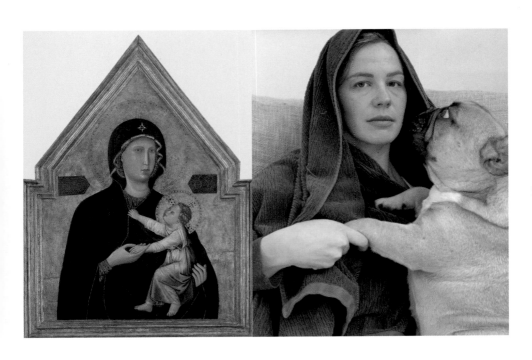

Master of Saint Cecilia
Madonna and Child, 1290–95

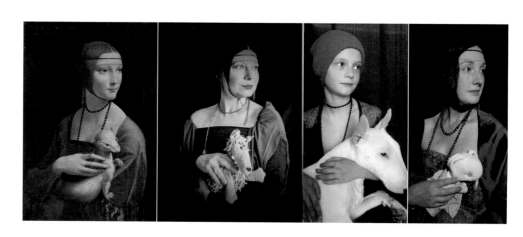

Leonardo da Vinci
Lady with an Ermine, 1489–90

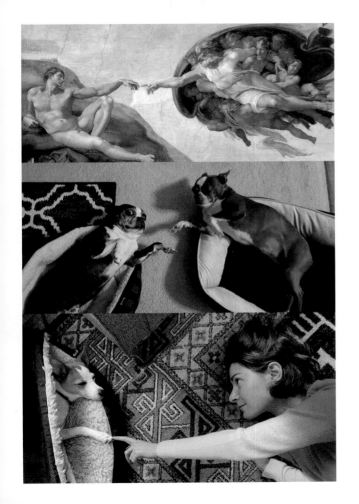

Michelangelo Buonarroti
The Creation of Adam, ca. 1508–12

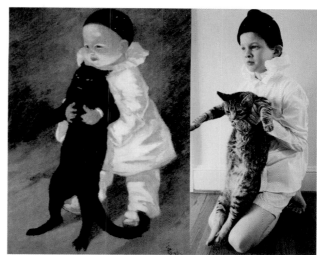

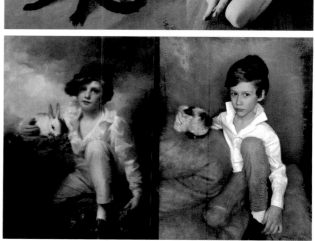

< Théophile Steinlen
Pierrot and the Cat, 1889

> Henry Raeburn
Boy and Rabbit, 1814

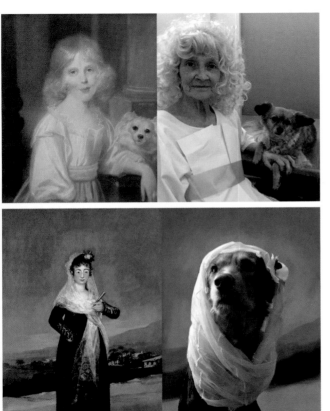

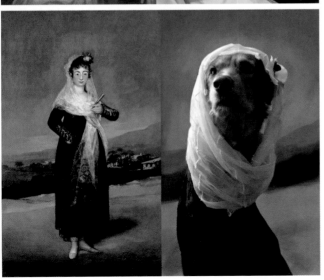

< John Russell
Portrait of a Girl with White Dog, 1790

> Francisco de Goya y Lucientes
Portrait of the Marquesa de Santiago, 1804

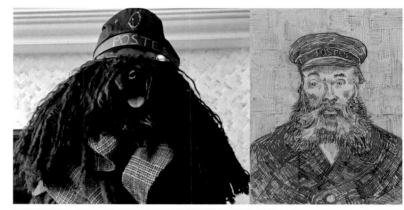
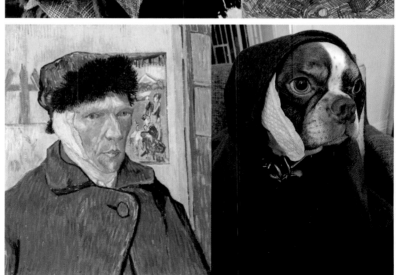

< Vincent van Gogh
Portrait of Joseph Roulin, 1889

> Vincent van Gogh
Self-Portrait with Bandaged Ear, 1889

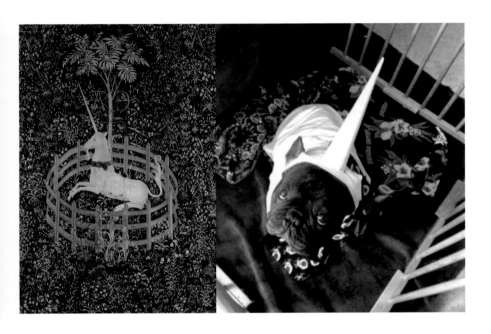

Unknown French Artist
The Unicorn Rests in a Garden, from the Unicorn
Tapestries, 1495–1505

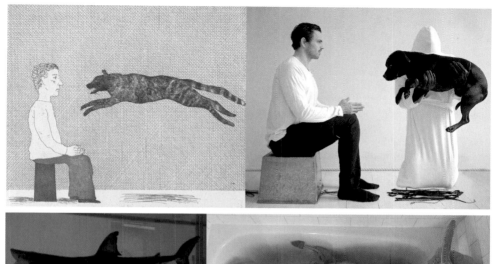

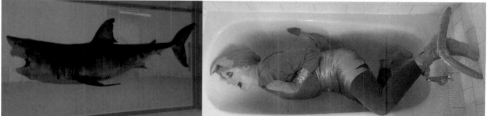

David Hockney
A Black Cat Leaping, from "Illustrations for Six Fairy Tales
from the Brothers Grimm," 1969

Damien Hirst
The Physical Impossibility of Death in the Mind of Someone Living, 1991

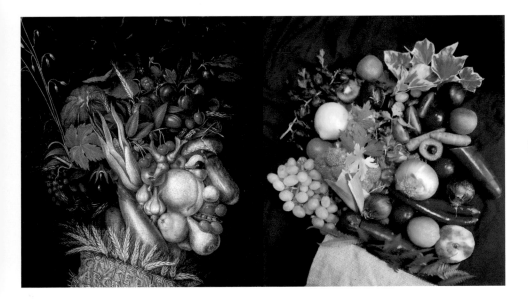

Giuseppe Arcimboldi
Summer, 1563

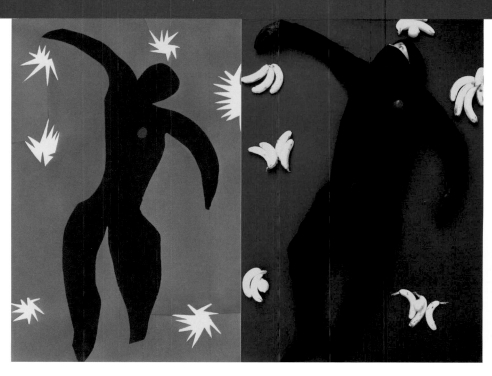

Henri Matisse
Icarus, from *Jazz*, 1947

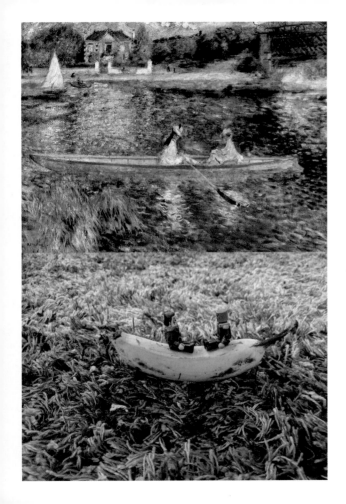

Pierre-Auguste Renoir
The Skiff, 1875

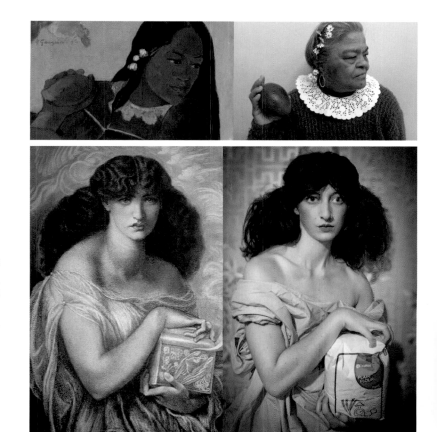

< Paul Gauguin
Woman of the Mango (detail), 1892

> Dante Gabriel Rossetti
Pandora, 1878–9

85

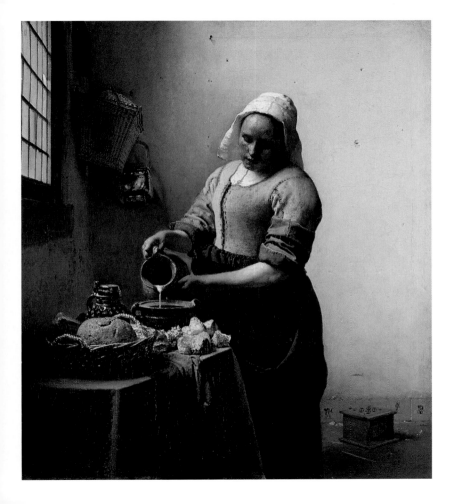

Johannes Vermeer
The Milkmaid, ca. 1660

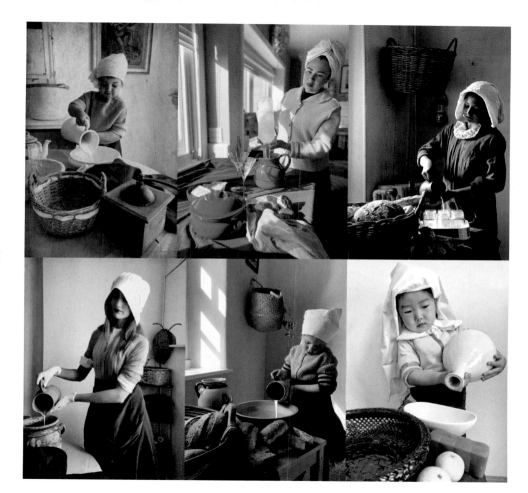

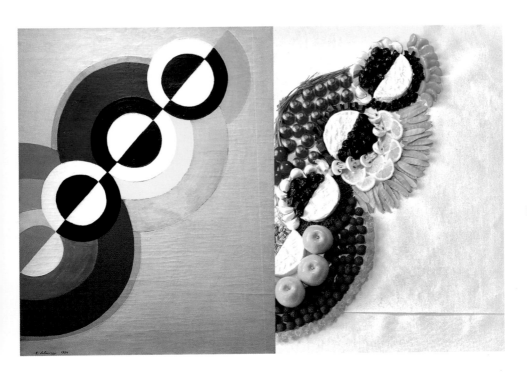

Robert Delaunay
Rhythms, 1934

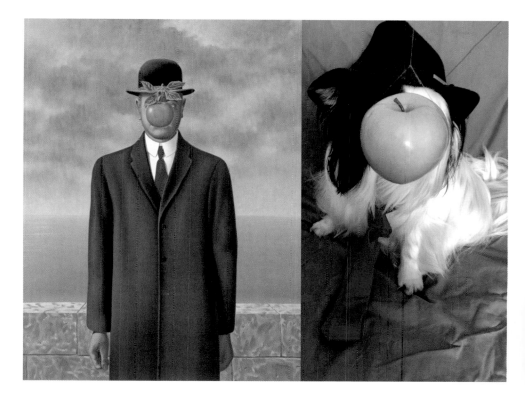

René Magritte
The Son of Man, 1964

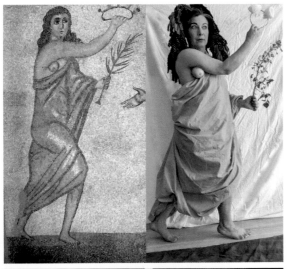

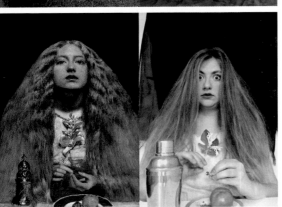

< Unknown Artist
Coronation of the Winner, early
4th century

> John Everett Millais
The Bridesmaid, 1851

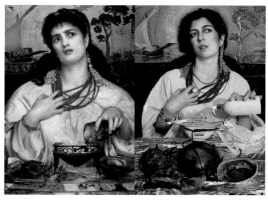

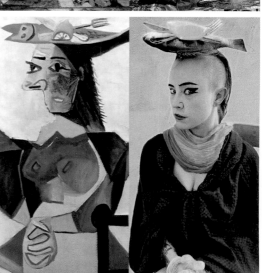

< Frederick Sandys
Medea, 1866–68

> Pablo Picasso
Seated Woman with Fish-Hat, 1942

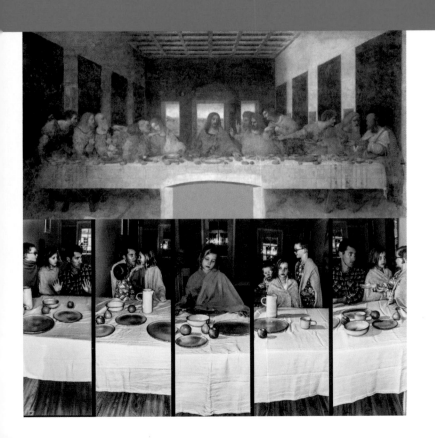

Leonardo da Vinci
The Last Supper, 1495–98

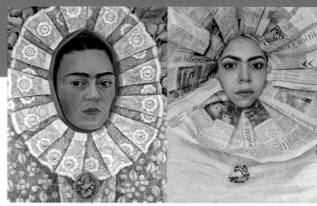

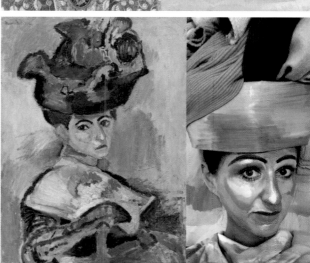

< Frida Kahlo
Self-Portrait, 1948

> Henri Matisse
Femme au chapeau, 1905

93

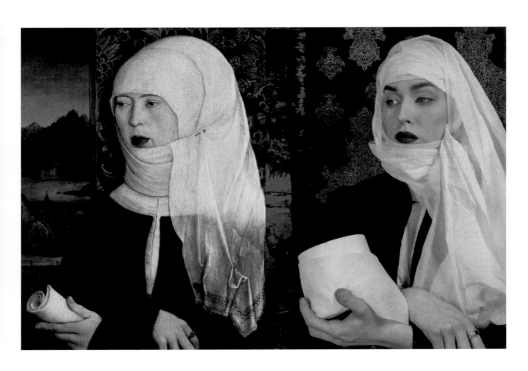

Bernhard Strigel
Portrait of Martha Thannstetter (née Werusin), ca. 1515

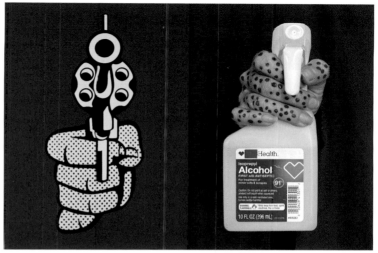

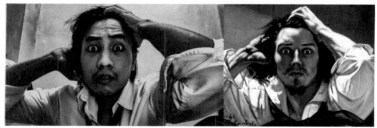

Roy Lichtenstein
Pistol, 1964

Gustave Courbet
The Desperate Man (Self-Portrait), 1843–45

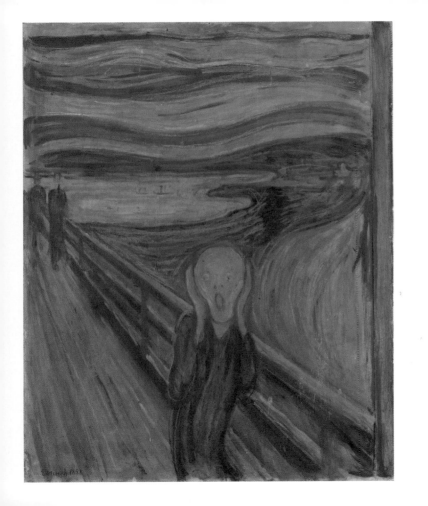

Edvard Munch
The Scream, 1893

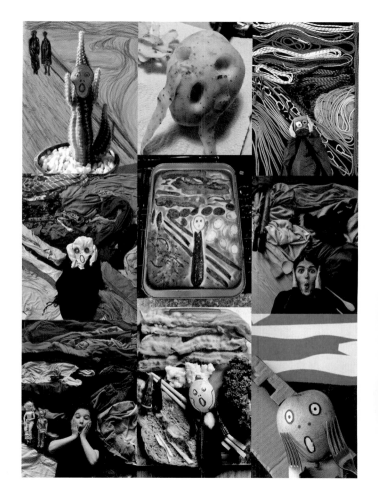

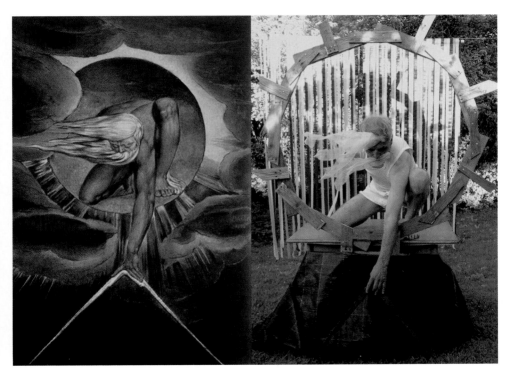

William Blake
The Ancient of Days, 1794

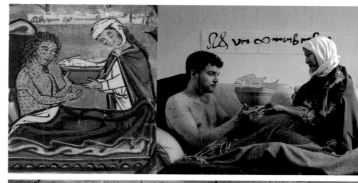

< Unknown Swiss Artist
Initial D: A Woman Feeding a Leper in Bed (detail), ca. 1275–1300

> Hieronymus Bosch
The Extraction of the Stone of Madness (detail), 1501–5

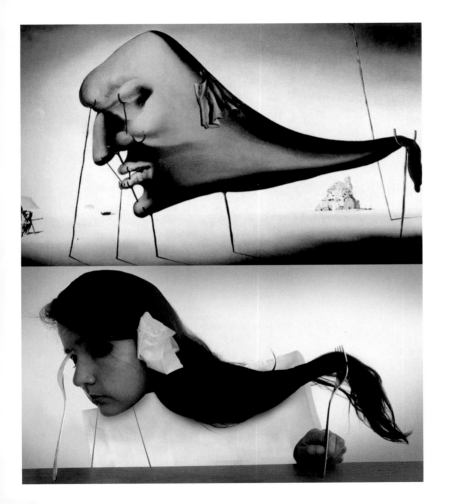

Salvador Dalí
Sleep, 1937

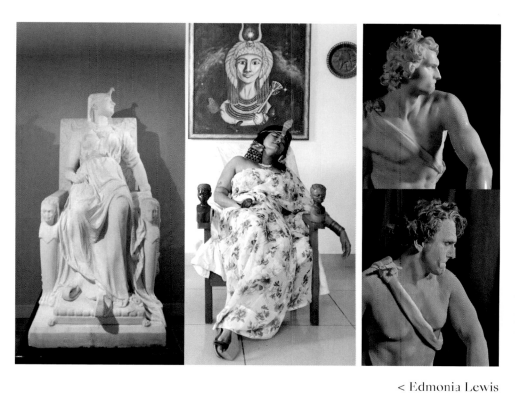

< Edmonia Lewis
The Death of Cleopatra, 1876

> Gian Lorenzo Bernini
David (detail), 1623–24

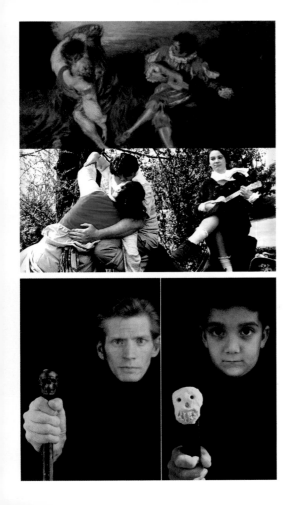

< Jean-Antoine Watteau
The Surprise (detail), 1718–19

> Robert Mapplethorpe
Self-Portrait, 1988

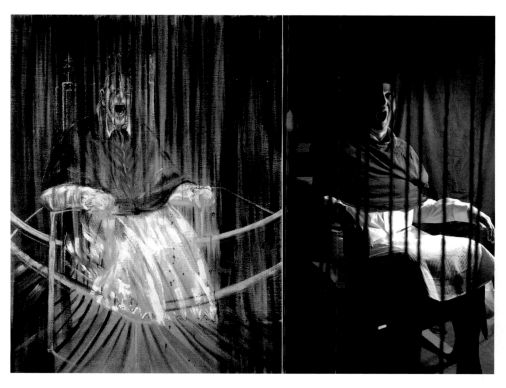

Francis Bacon
Study after Velázquez's Portrait of Pope Innocent X, 1953

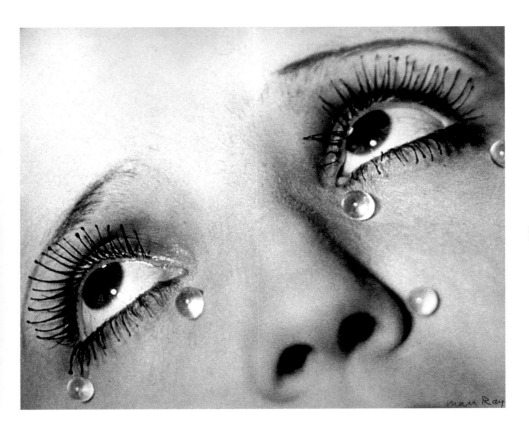

Man Ray
Tears, ca. 1932

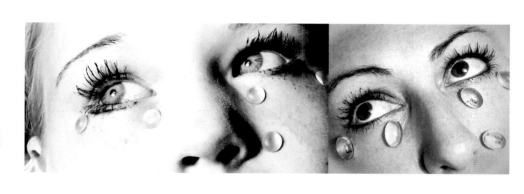

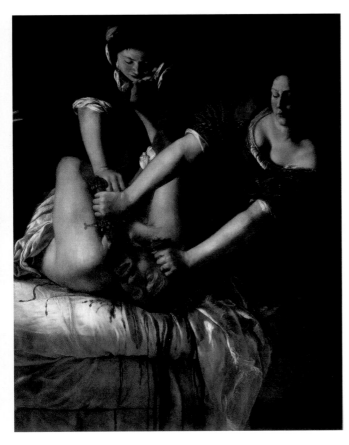

Artemisia Gentileschi
Judith Slaying Holofernes, ca. 1612–13

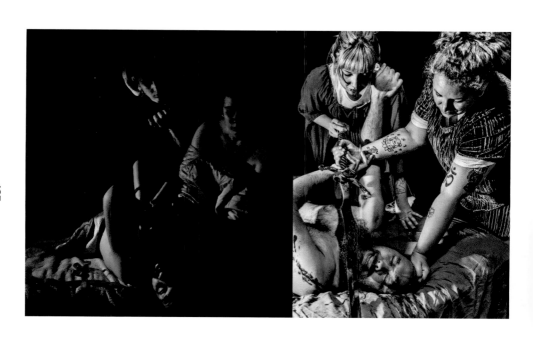

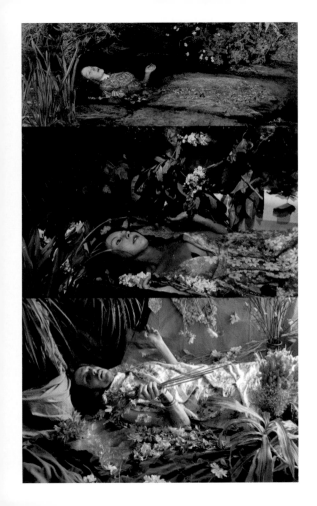

108

John Everett Millais
Ophelia (detail), 1851–52

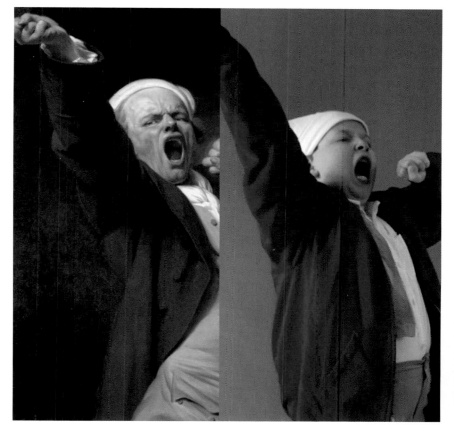

Joseph Ducreux
Self-Portrait, Yawning (detail), by 1783

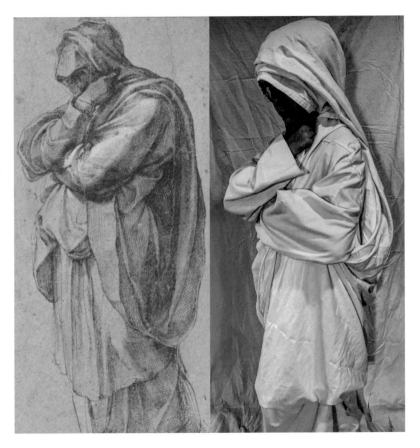

Michelangelo Buonarroti
Study of a Mourning Woman, ca. 1500–1505

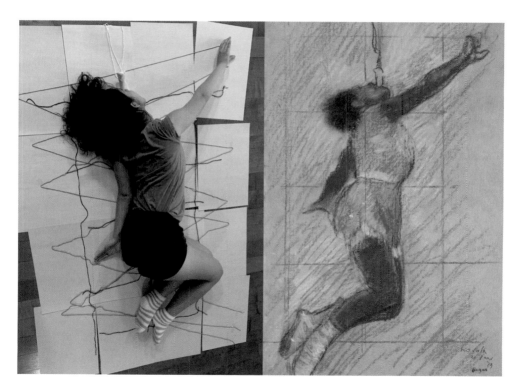

Edgar Degas
Miss Lala at the Fernando Circus, 1879

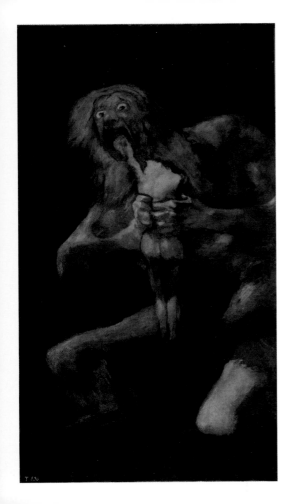

112

Francisco de Goya y Lucientes
Saturn Devouring His Son, ca. 1820–23

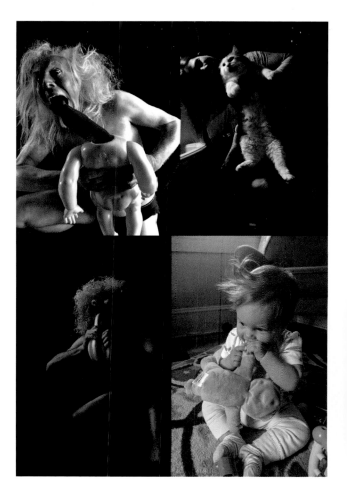

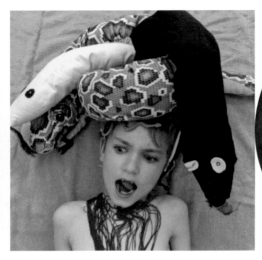
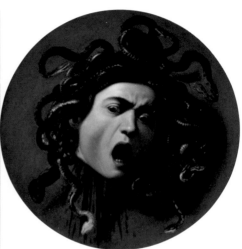

Michelangelo Merisi da Caravaggio
Medusa, 1597

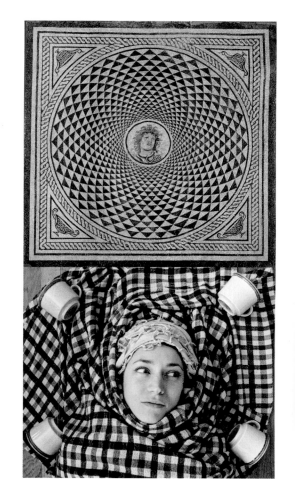

Unknown Artist
Mosaic Floor with Head of Medusa,
ca. 115–50

115

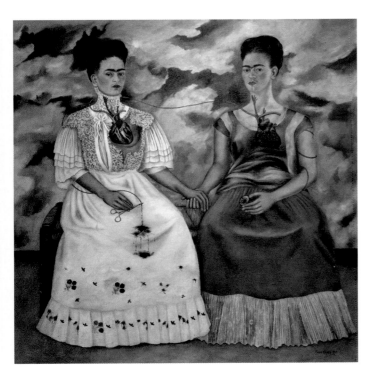

Frida Kahlo
The Two Fridas, 1939

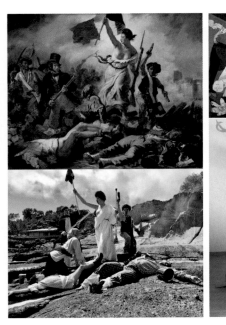

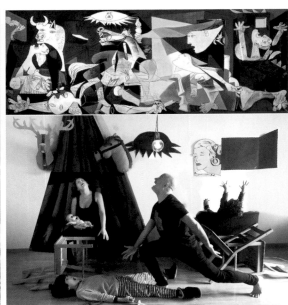

< Eugène Delacroix
Liberty Leading the People, 1830

> Pablo Picasso
Guernica, 1937

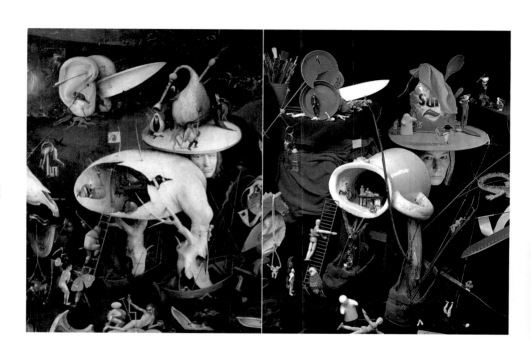

Hieronymus Bosch
The Garden of Earthly Delights (detail), 1490–1500

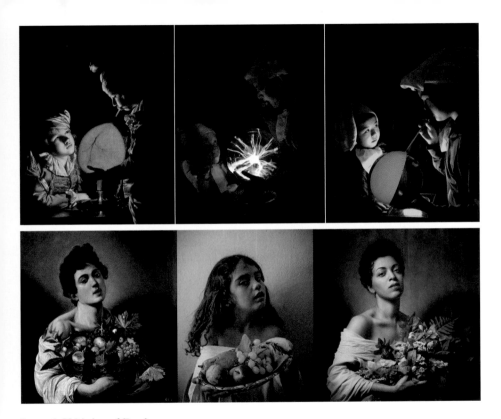

Joseph Wright of Derby
Two Boys with a Bladder, ca. 1769–70

Michelangelo Merisi da Caravaggio
Boy with a Basket of Fruit, ca. 1593

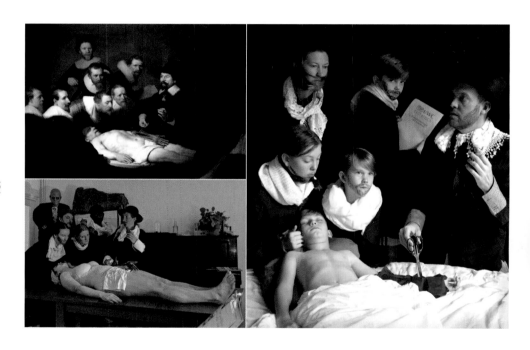

Rembrandt Harmensz. van Rijn
The Anatomy Lesson of Dr. Nicolaes Tulp, 1632

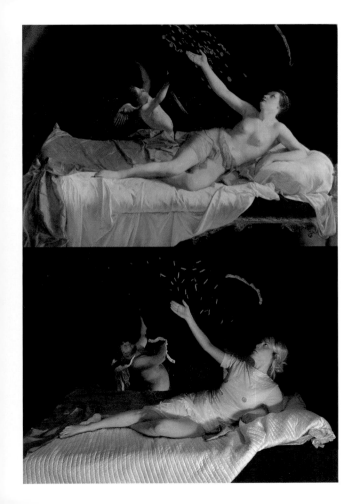

Orazio Gentileschi
Danaë and the Shower of Gold, 1621–23

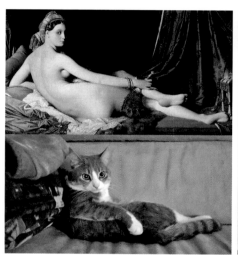

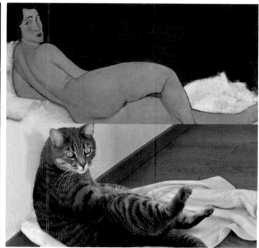

< Jean-Auguste-Dominique Ingres
La grande odalisque, 1814

> Amedeo Modigliani
Reclining Nude (On Left Side), 1917

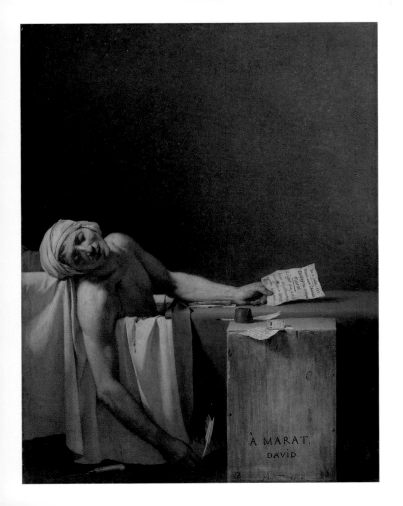

Jacques-Louis David
The Death of Marat, 1793

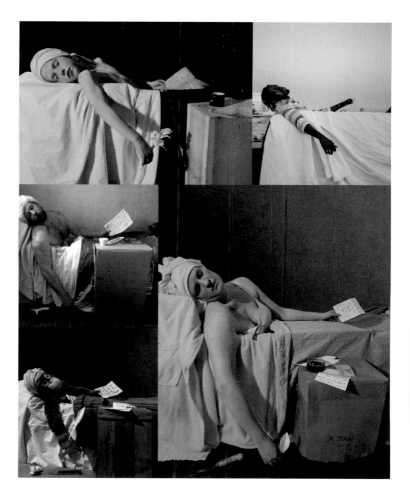

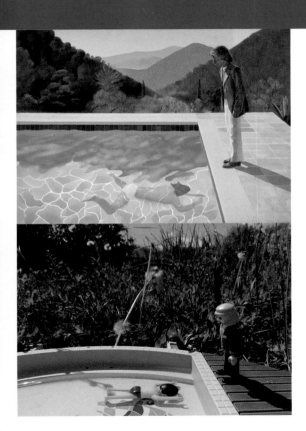

David Hockney
Portrait of an Artist (Pool with Two Figures), 1972

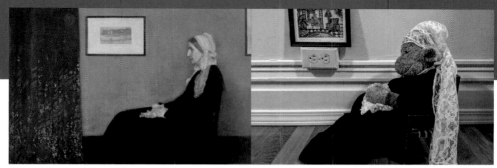

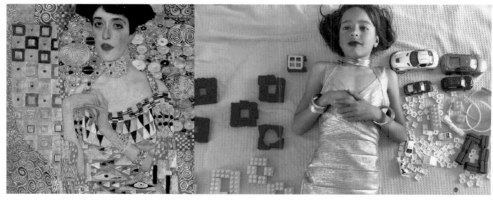

James Abbott McNeill Whistler
Arrangement in Grey and Black No. 1 (Portrait of the Artist's Mother), 1871

Gustav Klimt
Portrait of Adele Bloch-Bauer I (detail), 1907

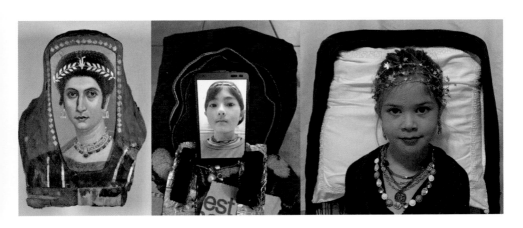

Attributed to the Isidora Master
Mummy Portrait of a Woman, 100

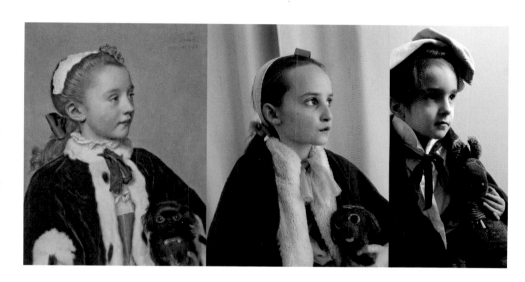

Jean-Étienne Liotard
Portrait of Maria Frederike van Reede-Athlone at Seven Years of Age (detail), 1755–56

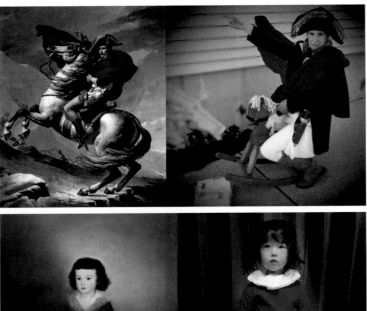

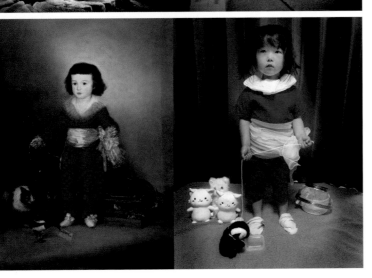

< Jacques-Louis David
Napoleon Crossing the Alps, 1801–5

> Francisco de Goya y Lucientes
Manuel Osorio Manrique de Zúñiga
(1784–1792), 1787–88

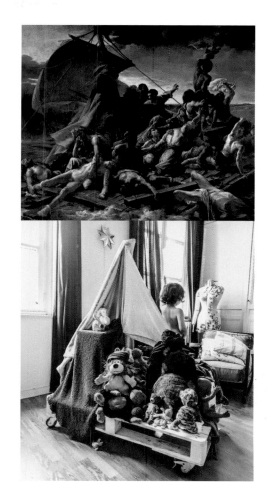

Théodore Géricault
The Raft of the Medusa (detail), 1818–19

131

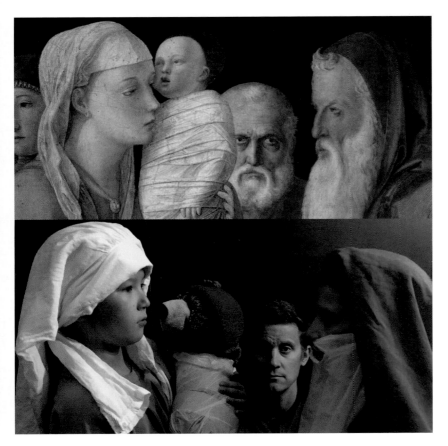

Giovanni Bellini
Presentation of Jesus at the Temple (detail), ca. 1460

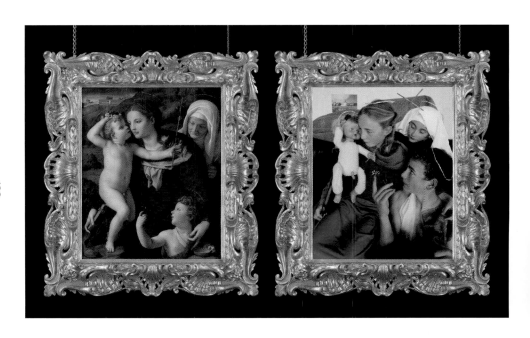

Agnolo Bronzino
Virgin and Child with Saint Elizabeth and Saint John the Baptist, ca. 1540–45

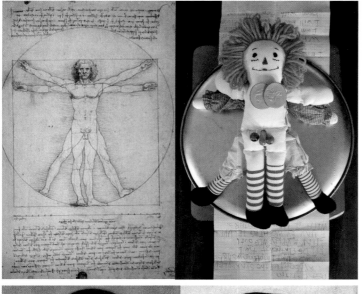

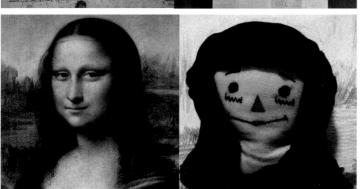

< Leonardo da Vinci
The Vitruvian Man, ca. 1490

> Leonardo da Vinci
Mona Lisa (detail), ca. 1503–19

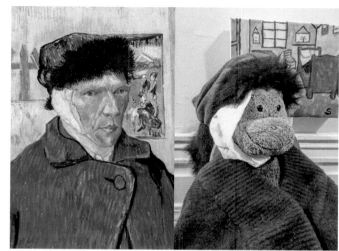

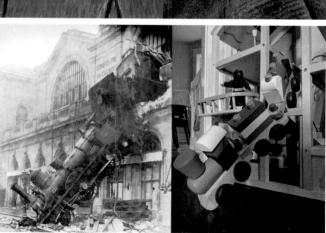

< Vincent van Gogh
Self-Portrait with Bandaged Ear, 1889

> Studio Lévy and Sons
Train Wreck at Montparnasse, 1895

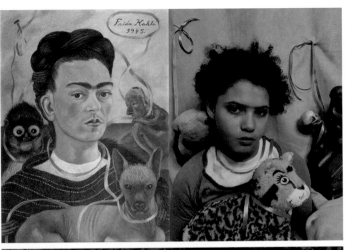

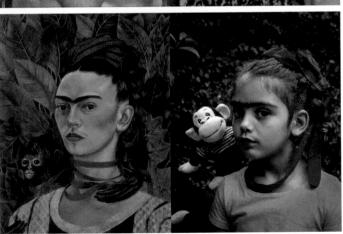

< Frida Kahlo
Self-Portrait with Small Monkey, 1945

> Frida Kahlo
Self-Portrait with Monkey, 1940

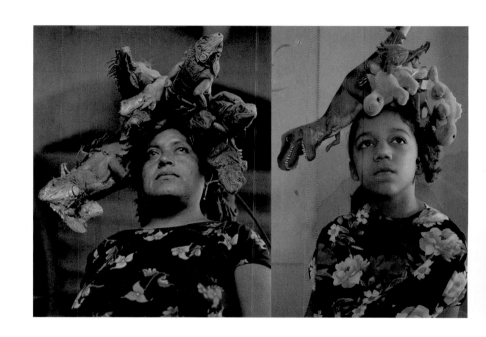

Graciela Iturbide
Our Lady of the Iguanas (detail), 1979

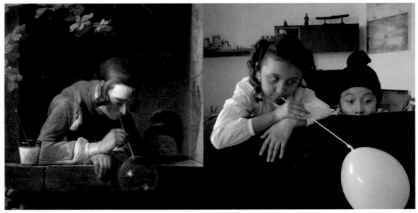

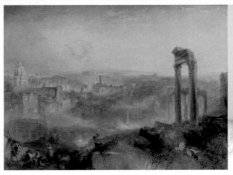

Jean-Siméon Chardin
Soap Bubbles, ca. 1733–34

Joseph Mallord William Turner
Modern Rome—Campo Vaccino, 1839

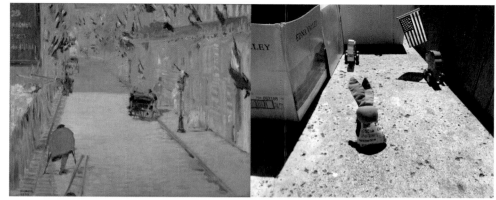

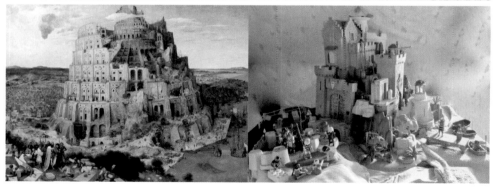

Édouard Manet
The Rue Mosnier with Flags, 1878

Pieter Bruegel the Elder
The Tower of Babel, ca. 1563

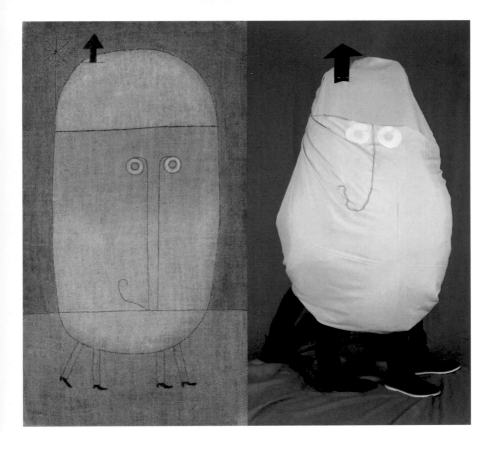

Paul Klee
Mask of Fear, 1932

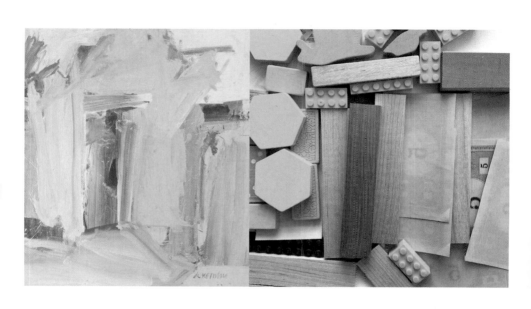

Willem de Kooning
Door to the River, 1960

Illustration Credits

© 2020 J. Paul Getty Trust
Third printing

Published by Getty Publications, Los Angeles
1200 Getty Center Drive, Suite 500
Los Angeles, California 90049-1682
getty.edu/publications

Rachel Barth, *Project Editor*
Victoria Barry, Laura diZerega, Zoe Goldman, and Ruth Evans Lane, *Editorial Team*
Catherine Lorenz, *Designer*
Clare Davis, *Production*

Distributed in the United States and Canada by the University of Chicago Press

Distributed outside the United States and Canada by Yale University Press, London

Printed in China

ISBN 978-1-60606-684-3 (pbk.)
ISBN 978-1-60606-685-0 (ebook)
Library of Congress Control Number: 2020938697

Illustration Credits

Every effort has been made to contact the owners and photographers of illustrations reproduced here whose names do not appear in the captions or in the illustration credits listed on pages 142–44. Anyone having further information concerning copyright holders is asked to contact Getty Publications so this information can be included in future printings.

MIX
Paper from responsible sources
FSC® C008047
www.fsc.org